ALBERTA LANDSCAPES

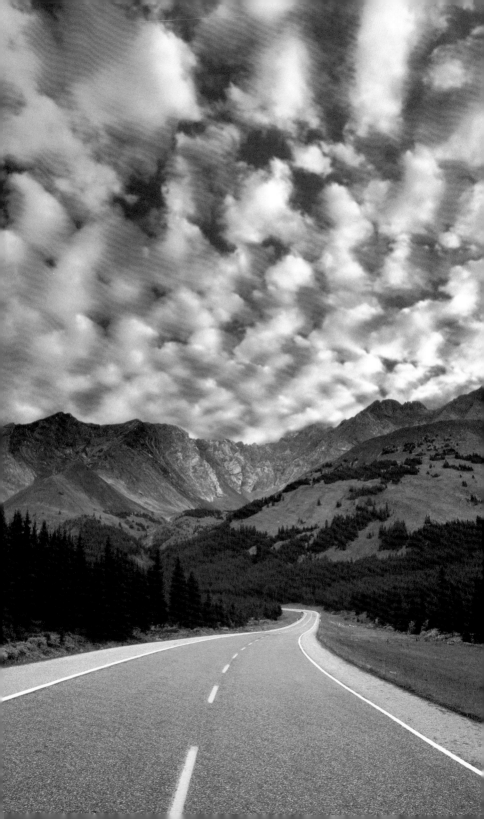

AMAZING PHOTOS™

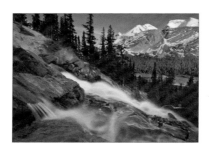

ALBERTA
LANDSCAPES

Darwin Wiggett

ALTITUDE PUBLISHING

Published by Altitude Publishing Canada Ltd.
1500 Railway Avenue, Canmore, Alberta T1W 1P6
www.altitudepublishing.com
1-800-957-6888

Extreme care has been taken to ensure that all information presented
in this book is accurate and up to date. Neither the photographer nor
the publisher can be held responsible for any errors.

Publisher Stephen Hutchings
Associate Publisher Kara Turner
Design and Photo Editing Stephen Hutchings
Editor Diana Marshall
Layout Bryan Pezzi

We acknowledge the financial support of the Government of Canada
through the Book Publishing Industry Development Program (BPIDP)
for our publishing activities.

 Altitude GreenTree Program: Altitude Publishing will plant twice
as many trees as were used in the manufacturing of this product.

Library and Archives Canada Cataloguing in Publication

Wiggett, Darwin, 1961-
 Alberta landscapes / Darwin Wiggett.

(Amazing photos)
ISBN 1-55439-612-3

 1. Alberta--Pictorial works. I. Title. II. Series.

FC3662.W565 2006 971.23′040222 C2006-903169-X

An application for the trademark for Amazing Photos™ has been made
and the registered trademark is pending.

Printed and bound in Canada by Friesens
2 4 6 8 9 7 5 3 1

INTRODUCTION

From the sagebrush-speckled lowlands to the boggy muskegs; from the barren moonscapes of the badlands to the frothing of white-water rapids; from the bustling skylines of its major cities to the towering wall of the Rocky Mountains, the landscapes of Alberta cast a seductive spell. Alberta is a province of natural and economic wealth, of diversity and community; it is urban and rural. It is a dynamic land of contrasts and of transformations.

No matter where the photographer's travels have taken him — locations as exotic and idyllic as they are distant — no place inspires him like Alberta. Darwin Wiggett was born and raised in Alberta, and he continues to make this province his home. His connection to his homeland is elemental. The natural, rugged beauty of this powerful landscape — crystal-clear lakes, endless rolling plains, and massive snow-capped mountains — has resulted in dramatic photography.

In this collection of photos, Darwin Wiggett tried to capture the *feel* of the land that he is so proud to call his home. He captures a land that stretches out to a horizon dotted with alpine peaks, grain elevators, and skyscrapers; a land of possibility. The spirit of Alberta moves and delights — it is hoped that the photographs will, too.

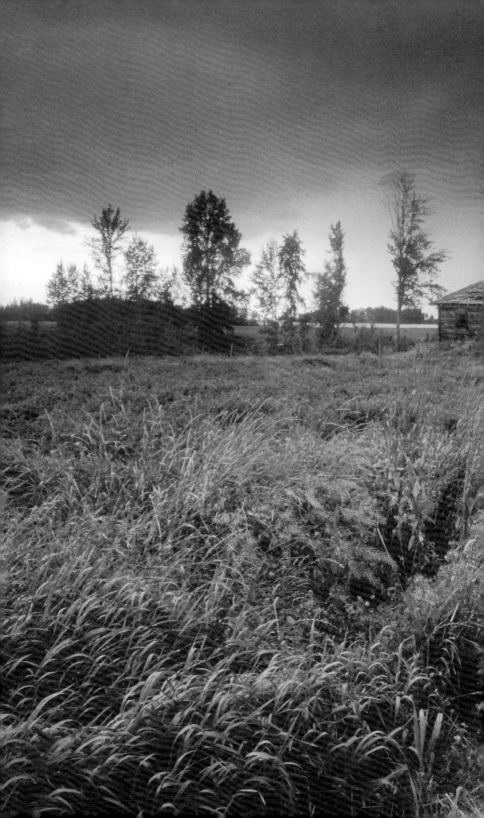

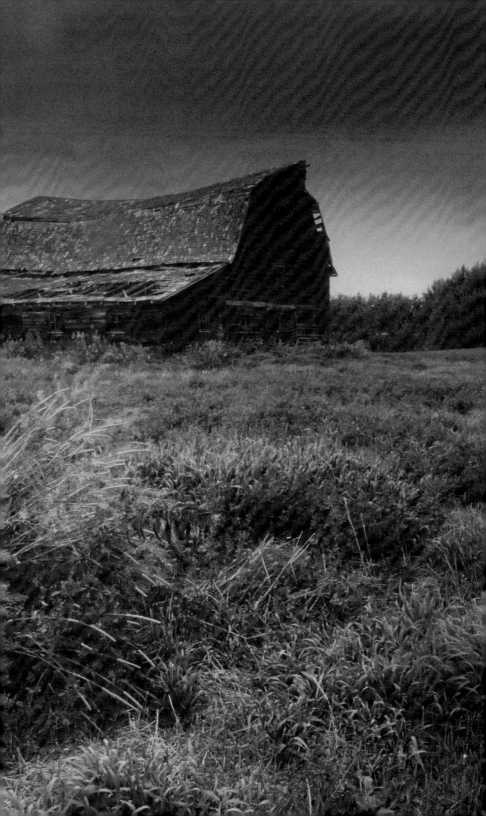

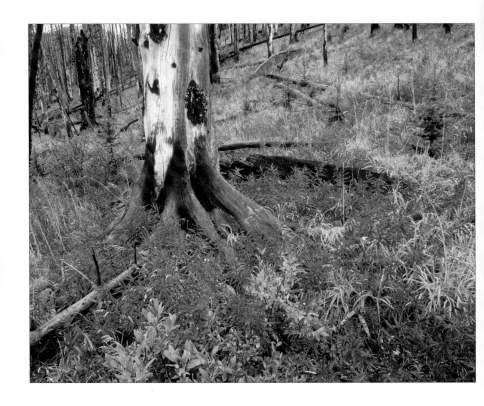

pages 6–7:
A spring thunderstorm, just passing through, colours the
sky above an abandoned barn and overgrown pasture
near Leduc.

above:
A 30-year-old forest burn in Willmore Wilderness Park is
saturated with the flaming colours of fireweed. Fireweed
thrives in recent burn areas, and presents an incredible
display of orange and red.

opposite:
The day's first light effuses the ramparts at Surprise Point in
Tonquin Valley, Jasper National Park.

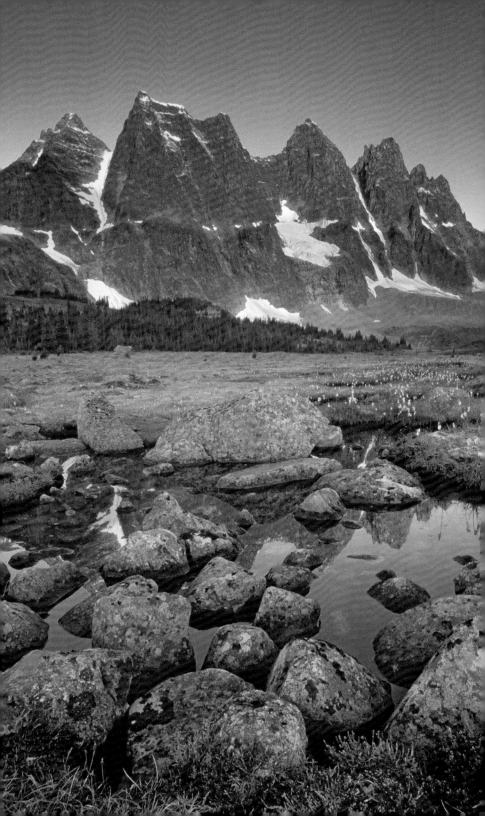

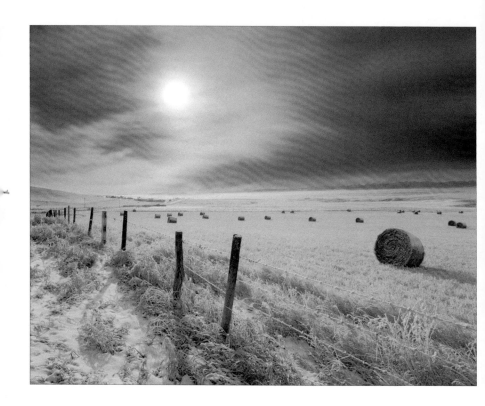

above:
The low winter sun shines weakly through a patchy sky, lighting this field of hay bales near Cochrane. A light dusting of snow alludes to the season.

opposite:
A chinook arch dominates the sky above a late winter pasture along the Grand Valley Road near Cochrane. According to popular myth, "chinook" is said to mean "snow eater." Albertans have come to love these warm winds that offer short reprieves during long, frigid winters.

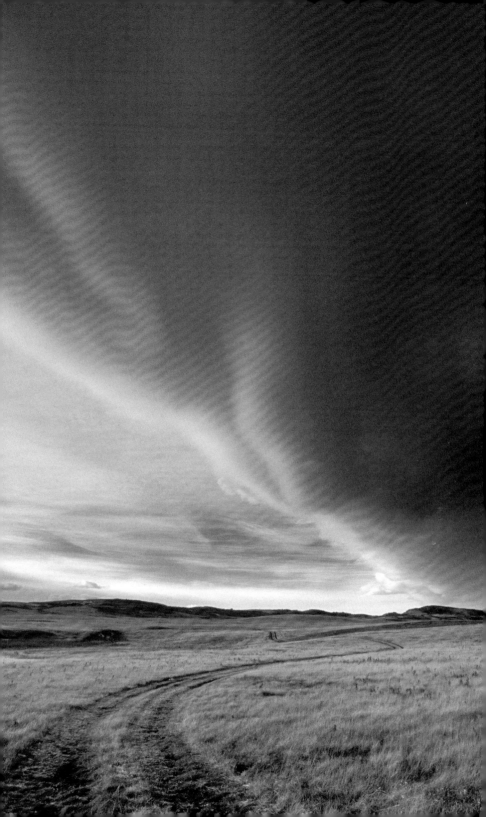

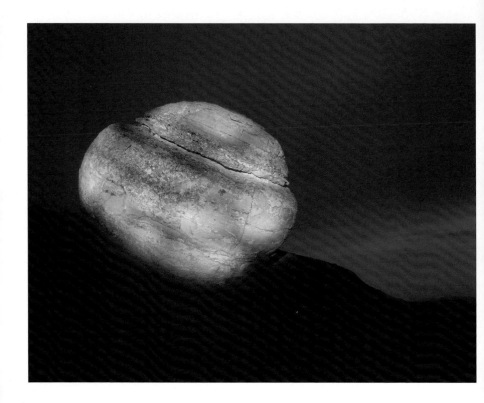

above:
The unique landscape at Red Rock Coulee Natural Area, near
the hamlet of Seven Persons, is dry, barren, and inhospitable.
A large boulder looks hauntingly spectral when caught in
the path of a flashlight at dusk.

opposite:
UNESCO World Heritage Site Dinosaur Provincial Park, deep
in Alberta's badlands, offers visitors a chance to discover
ancient fossils and dramatic geological formations, such as
these erosion rivulets in sandstone. The shapes of the clouds
mirror the patterns carved into the rock.

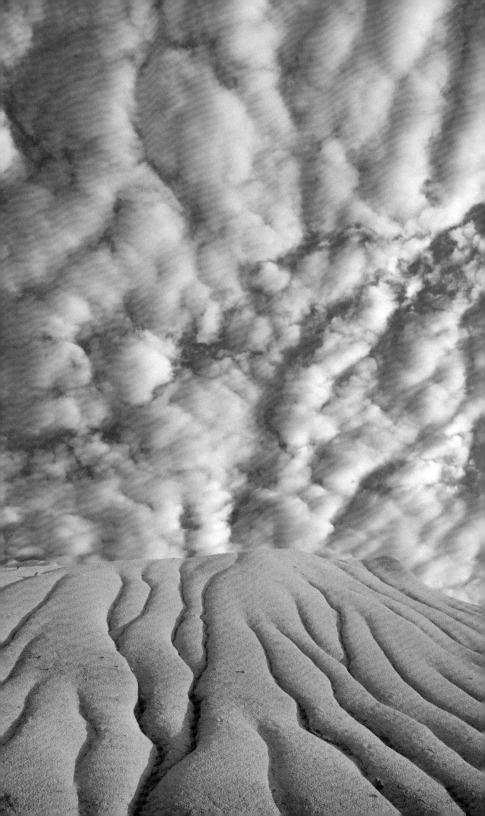

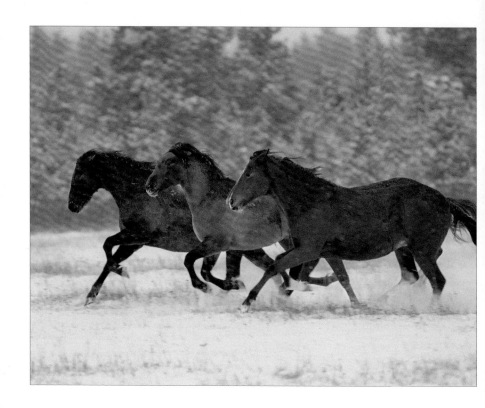

above:
This painterly trio of horses pounds the fresh snow in a pasture near Calgary. They were supporting players in a larger scene that included yipping coyotes and a screeching red-tailed hawk.

opposite:
Autumn leaves and a sunset-tinged sky splash colours across Dry Island Buffalo Jump Provincial Park in central Alberta. Cree hunters used to stampede bison over the area's high cliffs, known as buffalo jumps.

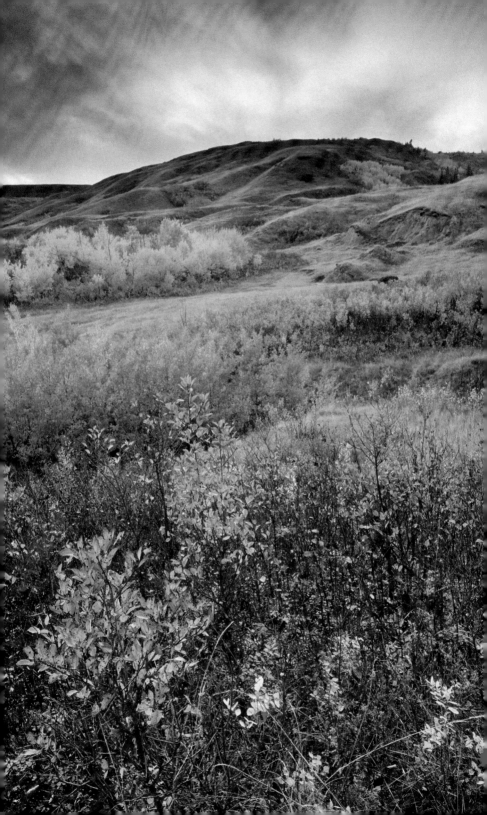

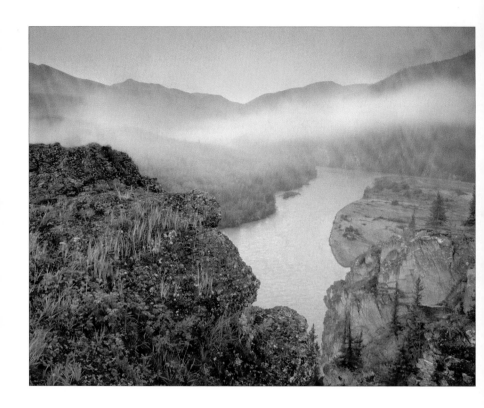

above:
A eerie morning fog rises over Hell's Gate on the Smoky River
near Grande Cache.

opposite:
Maligne River reflects the golden light of the winter sun near
Maligne Lake Road in Jasper National Park.

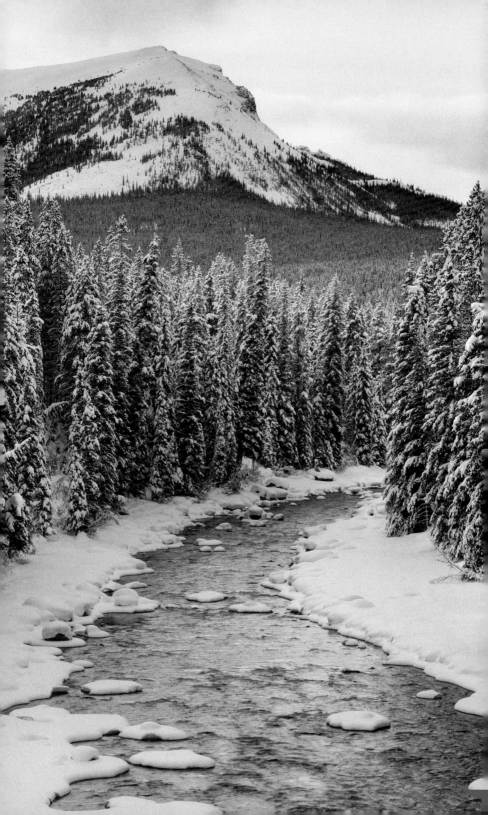

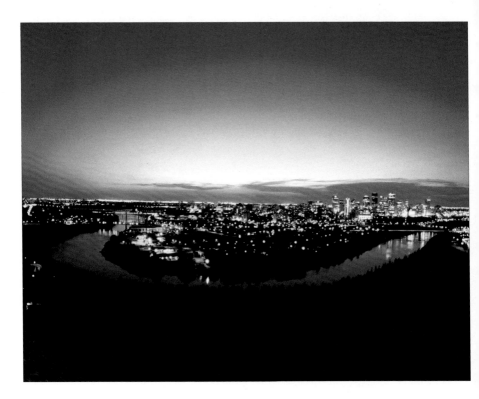

above:
A sparkling nighttime skyline offers a calm, sprawling view of Edmonton.

right:
The Ice Palace, in West Edmonton Mall, glistens with sun and skates all year round.

page 19:
The jagged beauty of Mount Kidd is a familiar landmark in Peter Lougheed Provincial Park, Kananaskis Country.

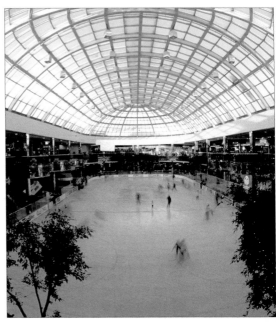

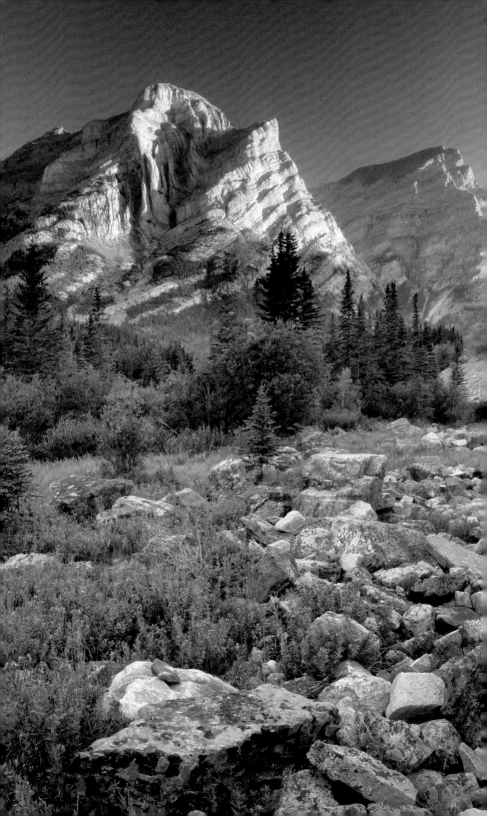

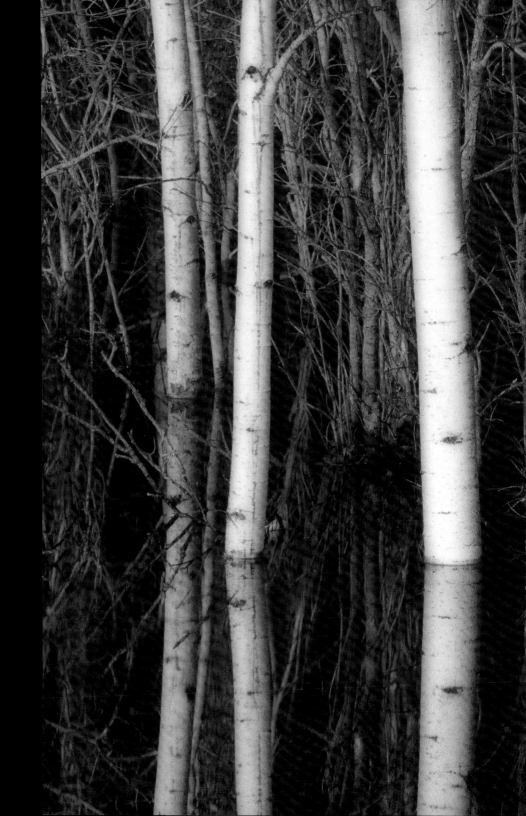

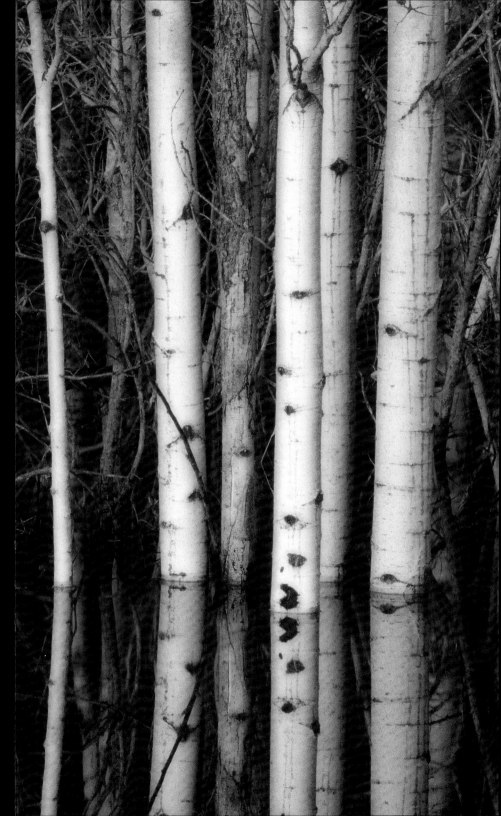

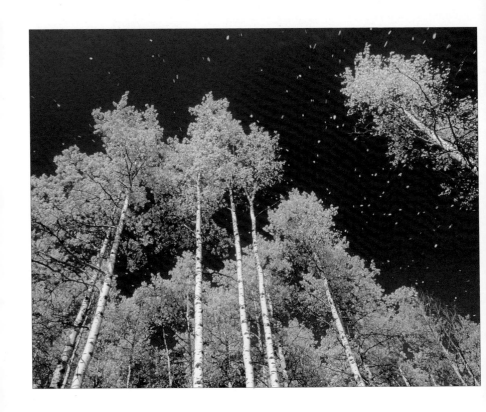

pages 20–21:
Heavy spring rains flooded this mixed poplar forest near Red Deer — a unique photo opportunity.

above:
Falling leaves flutter in the autumn sky above an aspen forest along the Sheep River near Turner Valley.

opposite:
Sandstone concretions dot the rolling prairie landscape in Red Rock Coulee Natural Area near Seven Persons.

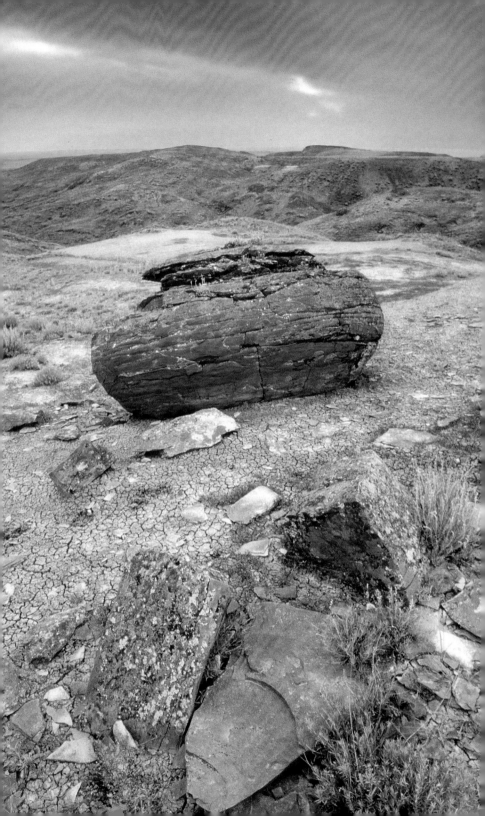

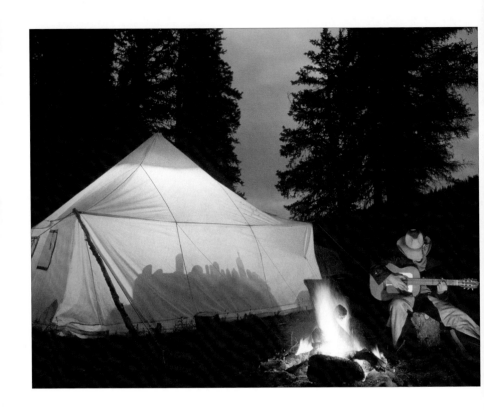

above:
A solitary wrangler strums a tune on his guitar after a long day on the trail in Willmore Wilderness Park.

opposite:
Car headlights cast beams of light across these spruce snags in an area flooded by a beaver dam along Highway 40 in Kananaskis Country.

pages 26–27:
Tidy rows of round bales flank the distant Canadian Rockies near big-sky Maycroft.

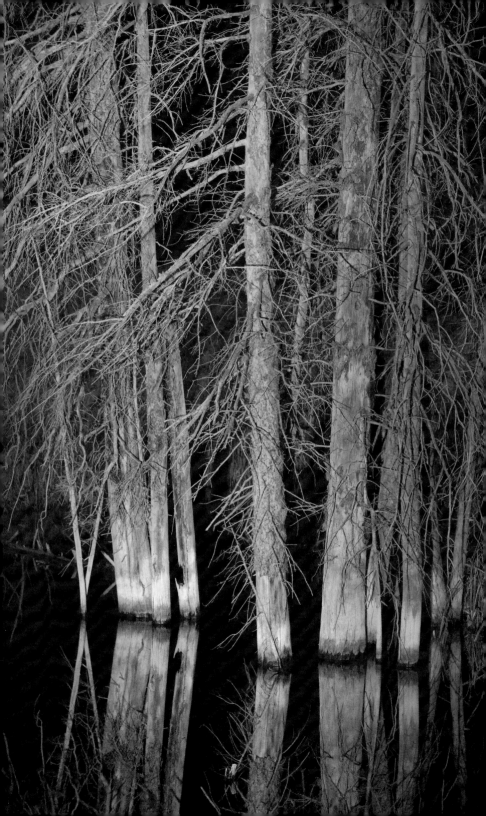

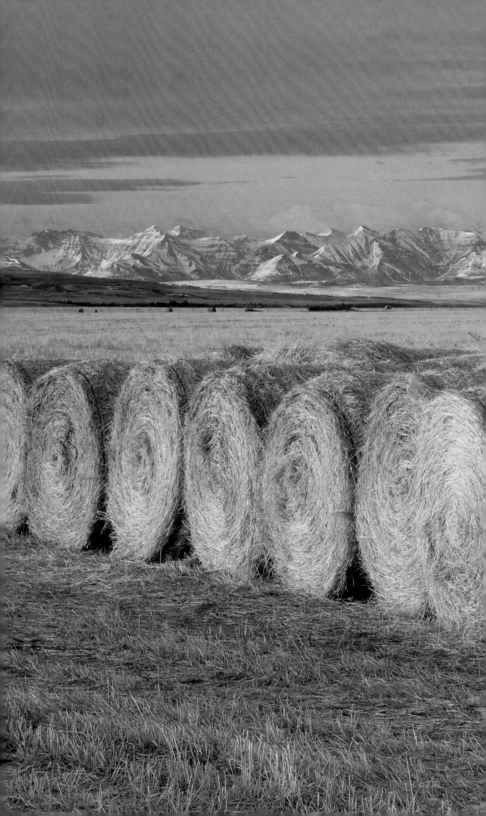

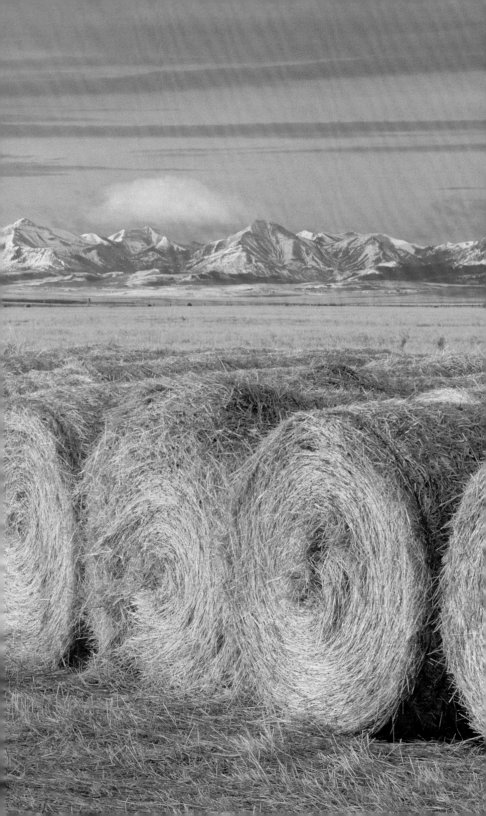

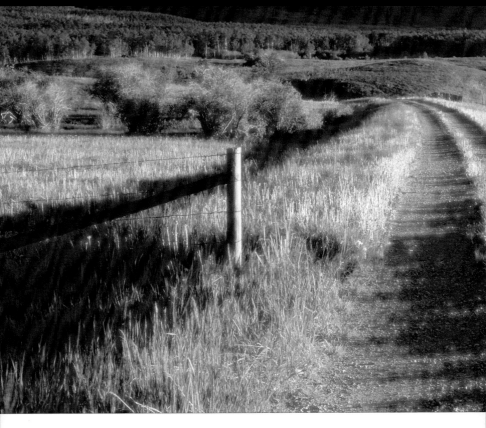

above:
The twin ruts of this pastoral road carve their way through the rolling foothills near Waterton Lakes National Park.

right:
A charming cartoon quality is captured in this cow's muzzle with the 180-degree field of vision of a fish-eye camera lens.

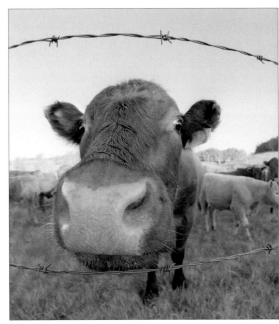

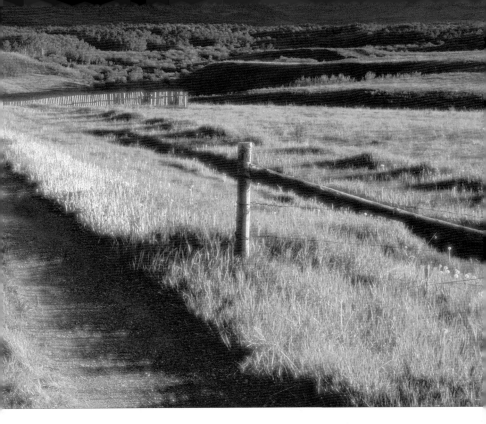

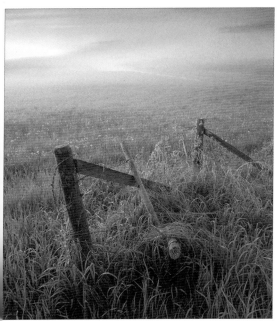

left:
A gnarled fence foregrounds the pale morning light in a pasture near Rollyview.

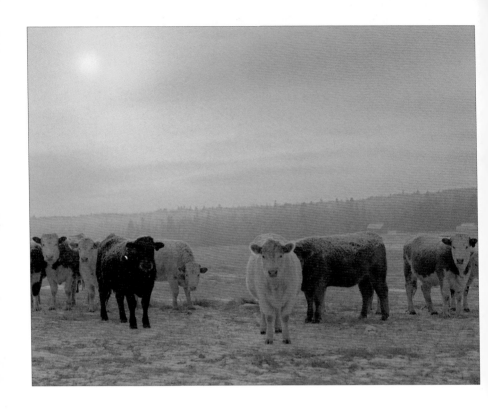

above:
A quiet moment is captured on New Year's Day as cattle
huddle on a snowy pasture near Water Valley.

opposite:
A gentle mist intersects Highway 22 as it snakes through
the foothills of the Rocky Mountains in Porcupine Hills.

pages 32–33:
Pyramid Mountain, near Jasper, is reflected in the
calm, glassy surface of Pyramid Lake, creating a still,
kaleidoscopic effect.

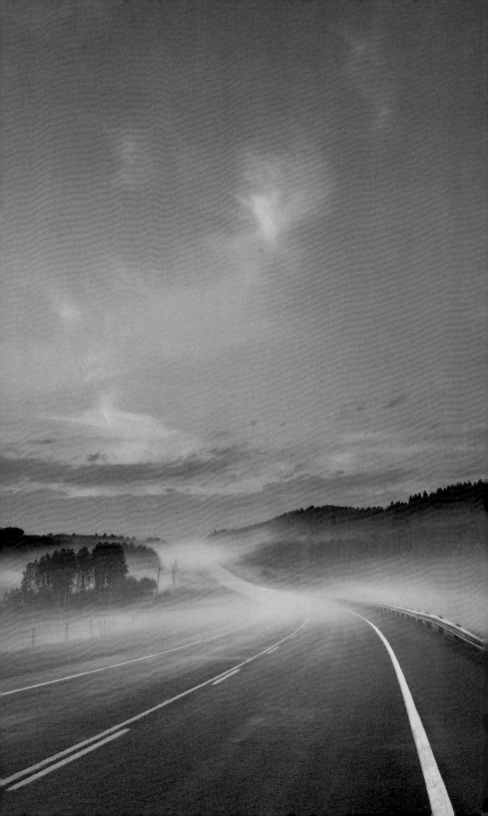

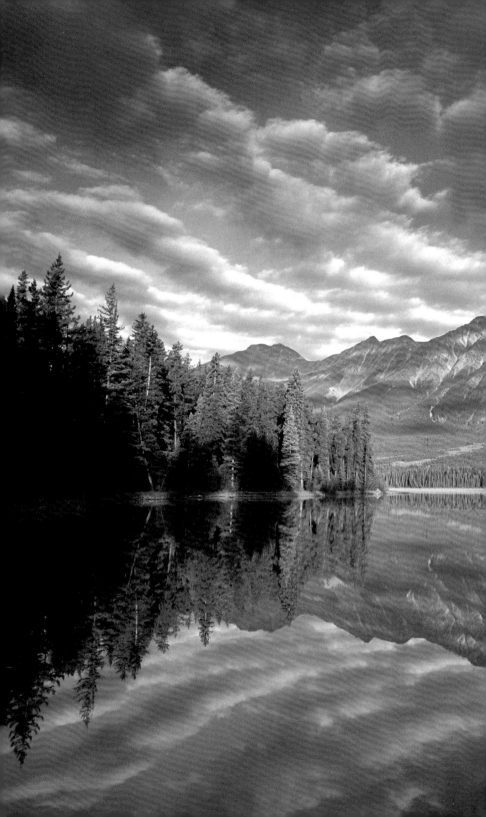

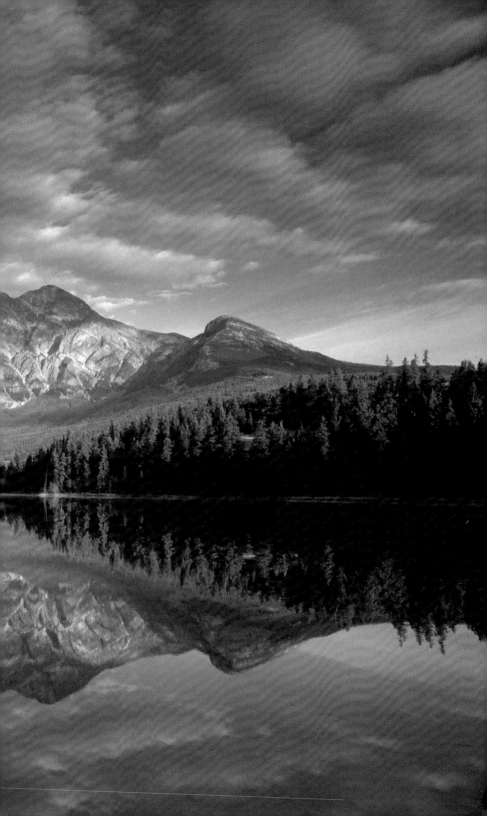

above:
A favourite
weekend destination
for Edmontonians
is nearby Elk Island
National Park. From
the shore of Astotin Lake,
a brilliant sunset lights
up both water and sky.

right:
Beams of light from a rising
sun penetrate the fog to
create "God's rays." The
moment, amid the aspen
trees in central Alberta,
takes on a spiritual tone.

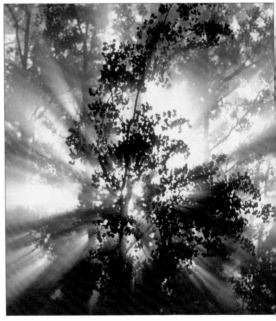

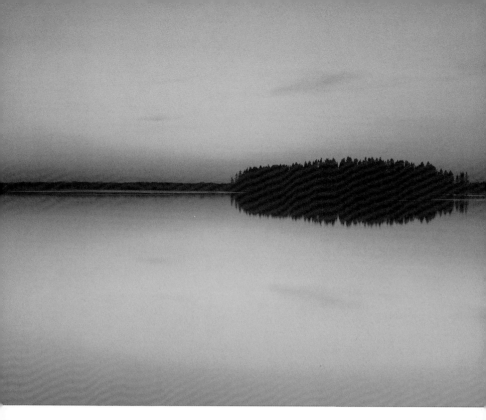

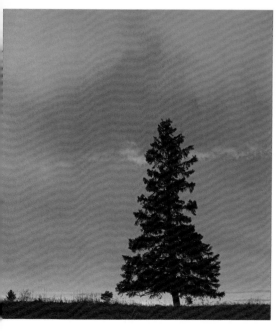

left:
Open range lands and scattered trees along Horse Creek Road, near Cochrane, provide plenty of opportunities for capturing dramatic silhouettes at sunset.

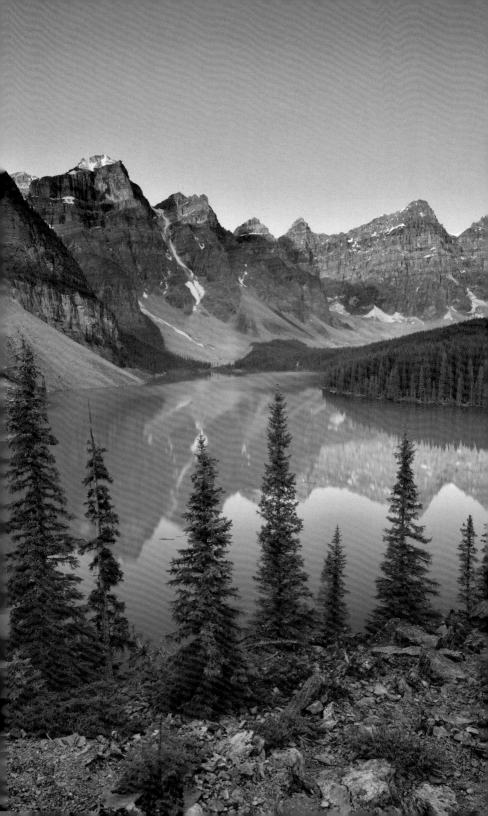

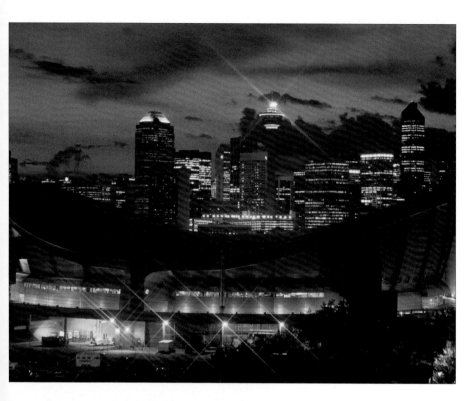

opposite:
Moraine Lake, in Banff National Park, is one of Canada's most photographed views.

above:
Calgary's skyline twinkles with light and colour.

left:
The city's glass skyscrapers reflect interpretations of the Calgary Tower.

pages 38–39:
November snow lightly dusts Moberly Flats in Jasper National Park.

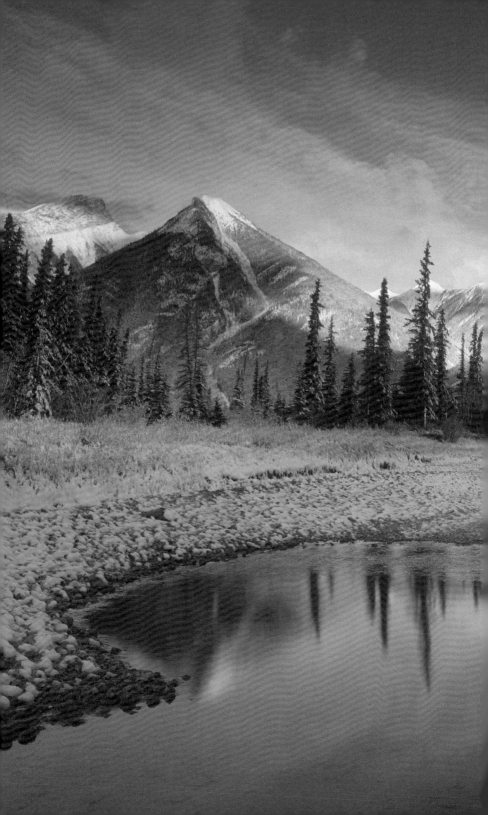

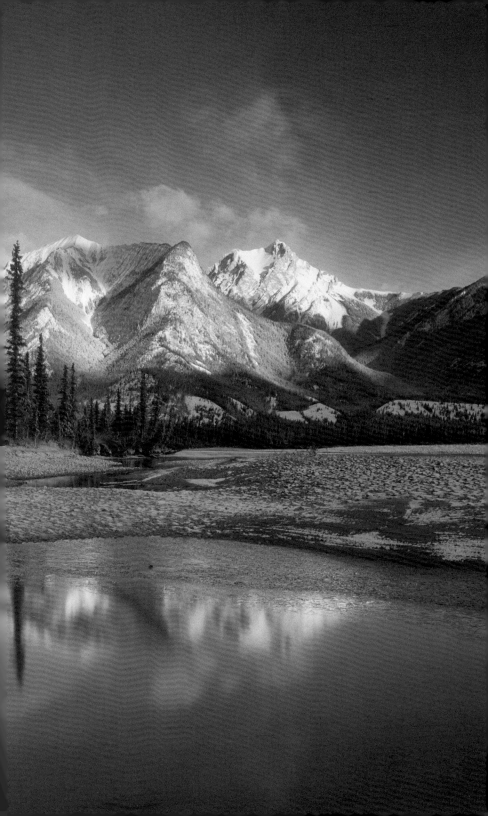

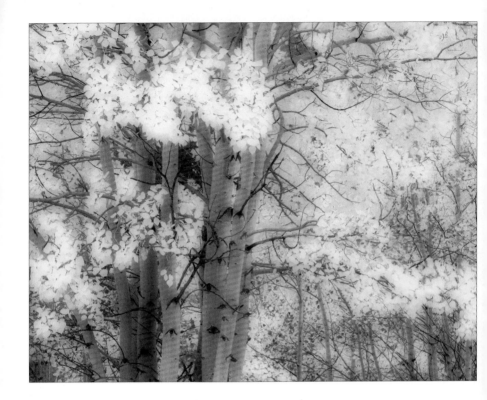

above:
The leaves of aspen trees whirl in a strong Kootenay Plains wind, just west of Nordegg.

opposite:
A canoe restlessly awaits its paddler on the shore of Winchell Lake near Water Valley.

pages 42–43:
Sky and land blend together at the horizon under a blanket of morning fog in a pasture near Camrose.

page 44:
The feeble winter sun casts long shadows across sparkling snow along Icefields Parkway, Banff National Park.

page 45:
The Miette Range of the Rocky Mountains can be seen in a hot spring in Jasper National Park.

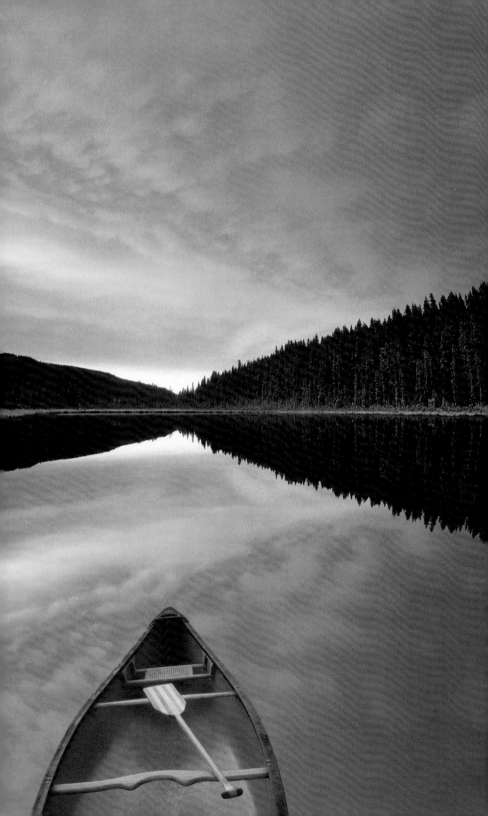

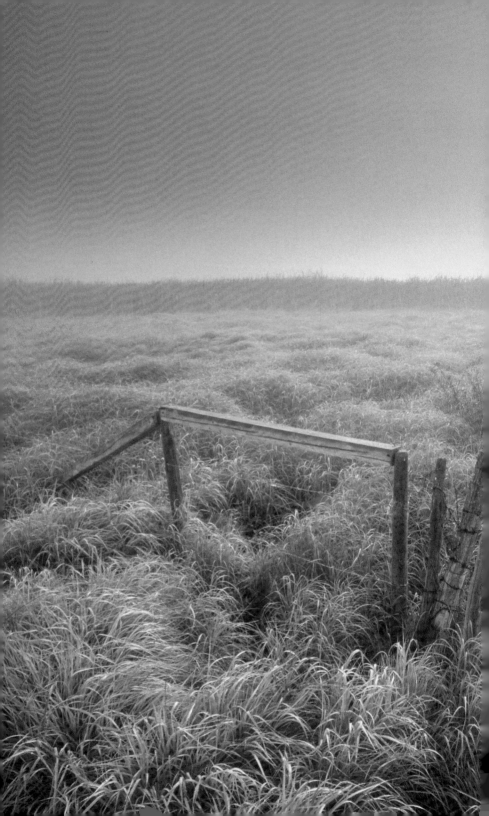

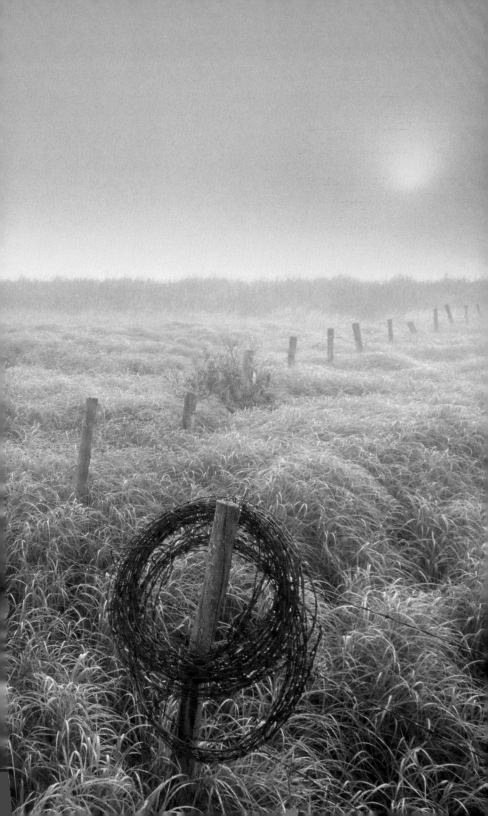

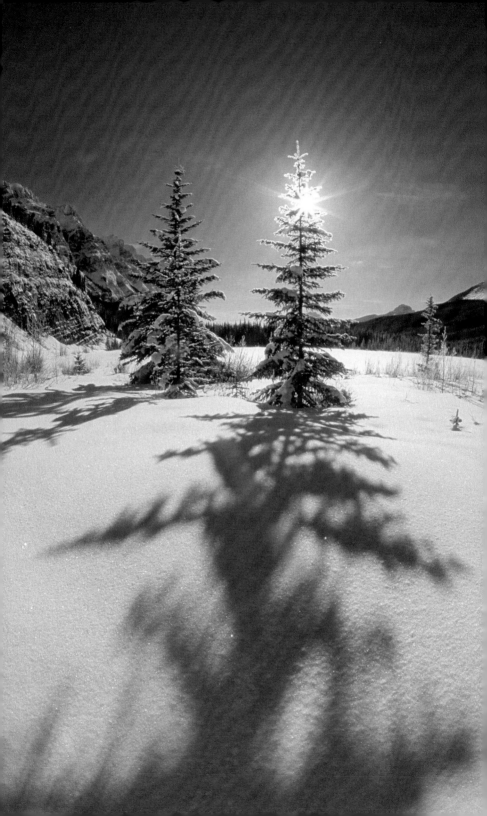

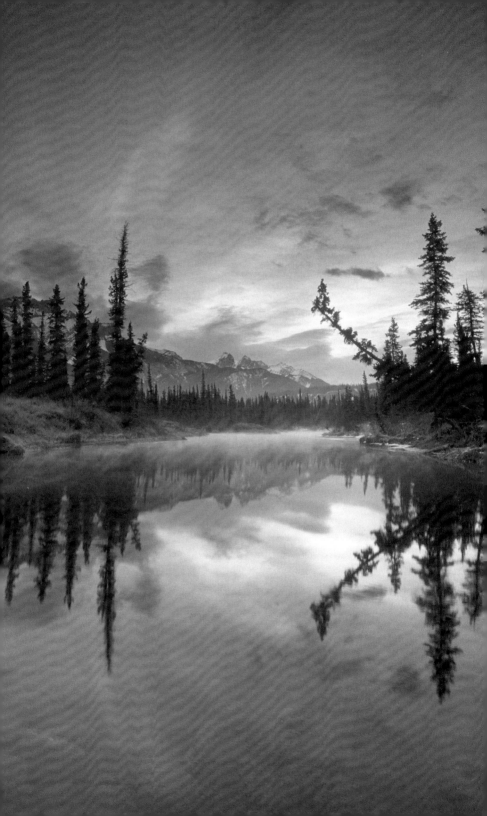

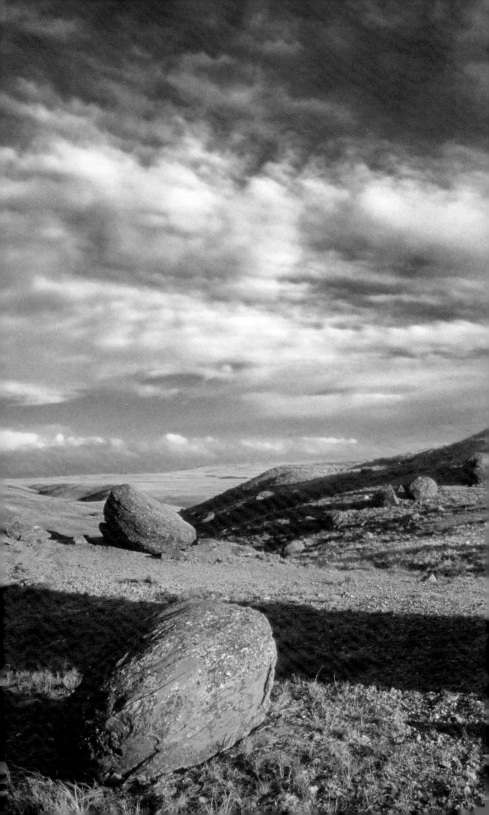

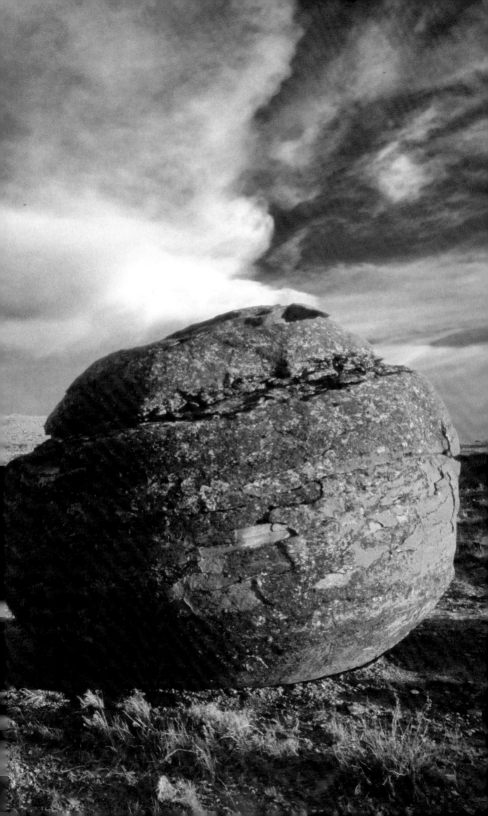

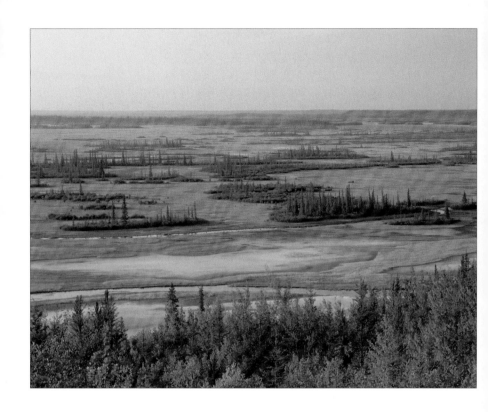

pages 46–47:
Concretions of sandstone punctuate an otherwise desolate
landscape of rolling prairies in Red Rock Coulee Natural Area
(photo by Anita Dammer and Darwin Wiggett).

above:
An aerial view of the salt flats in Wood Buffalo National Park
reveals the myriad of textures and patterns created by water,
salt, trees, and muskeg.

opposite:
A shimmering rainbow touches down behind a canola field
near Millet — a fitting finale after a summer downpour.

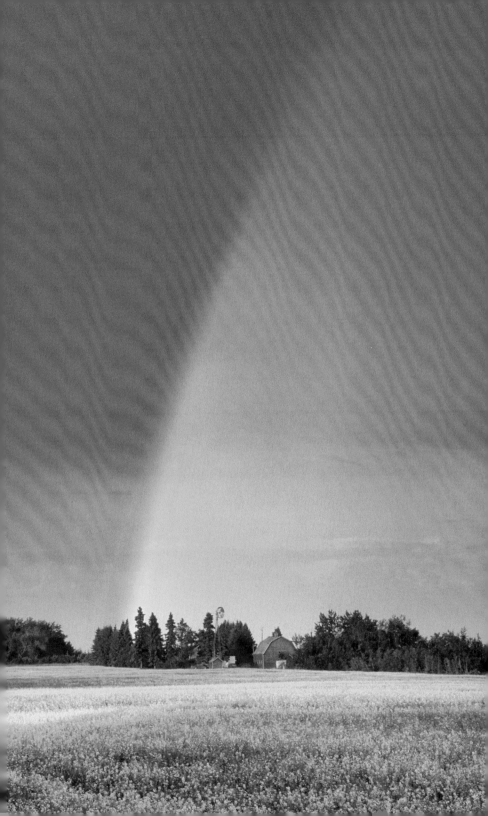

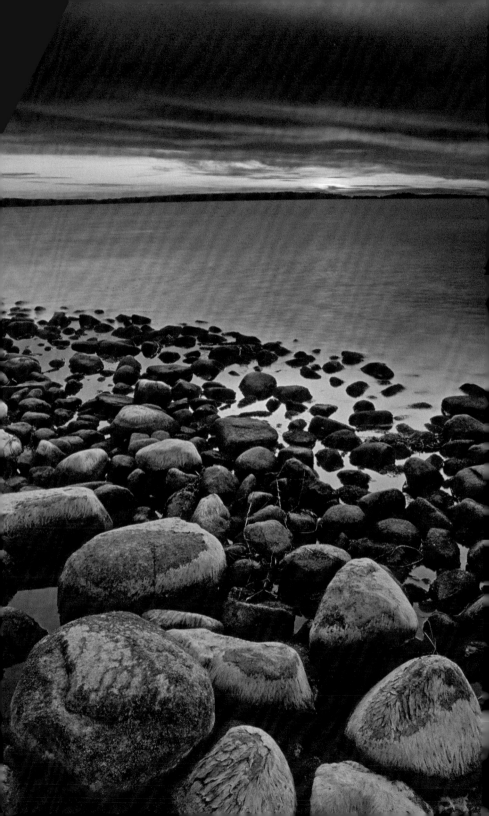

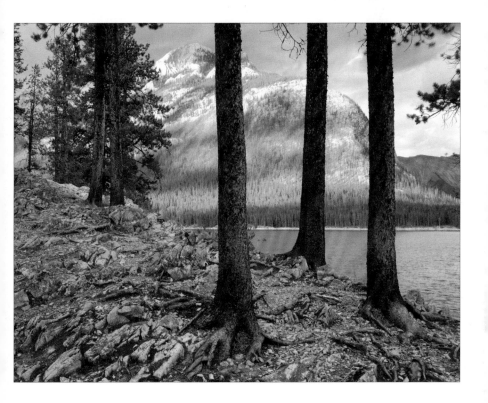

opposite:
A crowning sunset at Long Point, after a stormy day, adds a tinge of colour to an otherwise cold view of Lake La Biche in Sir Winston Churchill Provincial Park.

above:
A rock-and-tree shoreline delicately frames Lake Minnewanka, in Banff National Park, as cloud shadows playfully skitter across distant peaks.

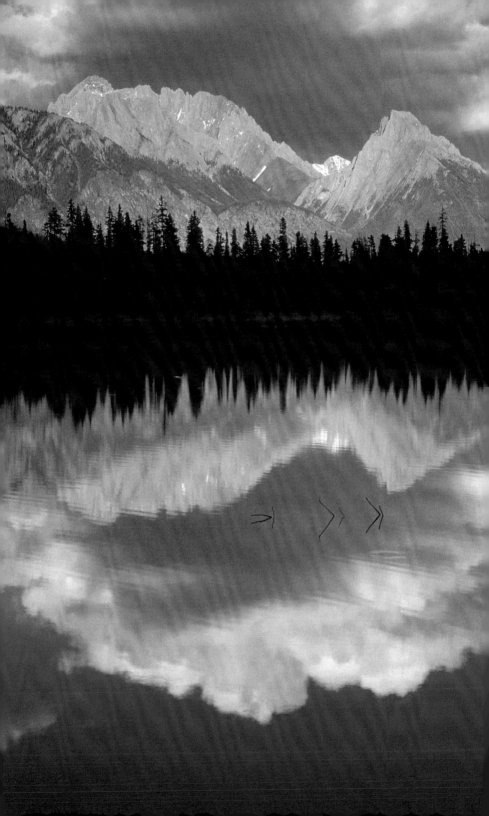

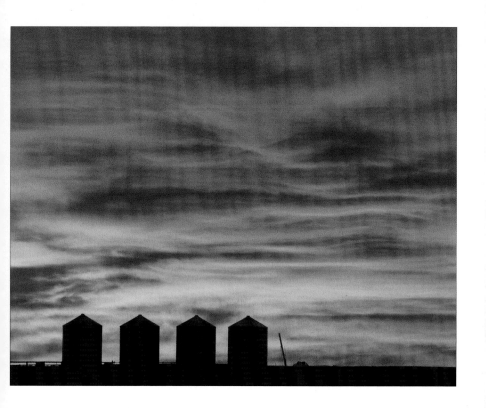

opposite:
The rippled surface of Spillway Lake reflects the Opal Range in Peter Lougheed Provincial Park, Kananaskis Country.

above:
An apocalyptic sunrise highlights some quintessentially Albertan architecture — granaries — in a calm prairie scene near Carstairs.

pages 54–55:
In an iconic Alberta view, the blue-green waters of Peyto Lake are nestled in beautiful Mistaya Valley, surrounded by towering peaks in Banff National Park.

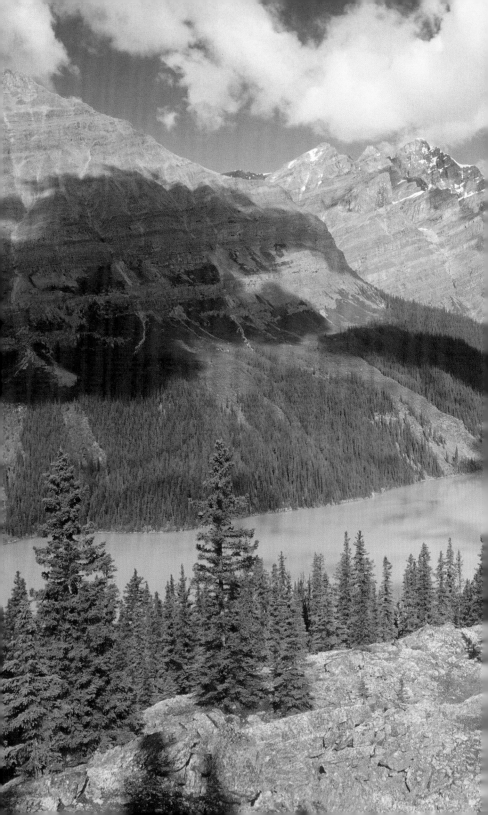

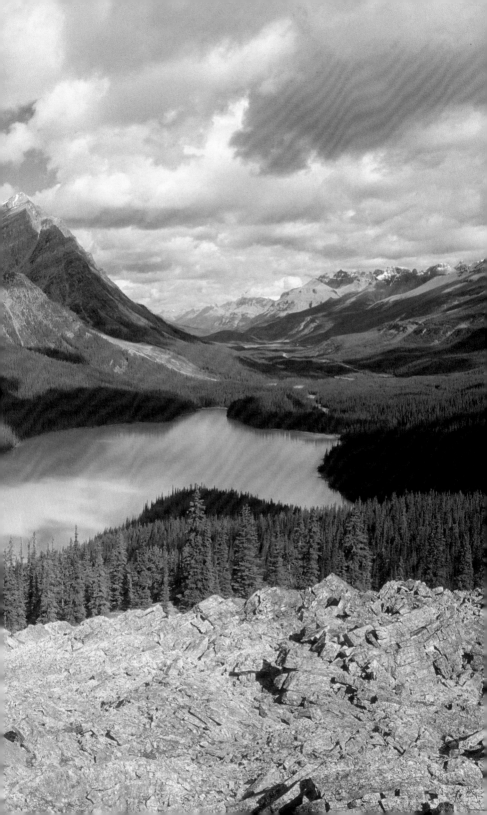

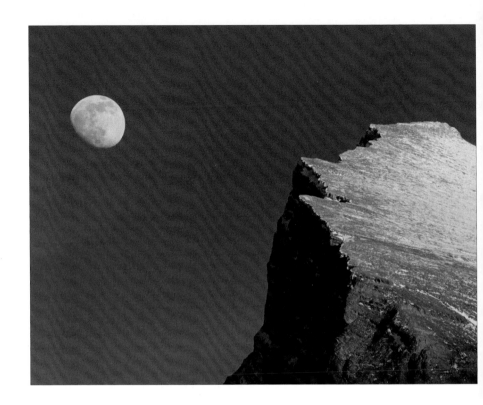

above:
A three-quarter moon rises up above the jagged shoulder of
Mount Rundle which overlooks the town of Banff.

opposite:
Known for being one of the greatest dinosaur fossil beds in
the world, the 75-million-year-old formations in Dinosaur
Provincial Park attract rock hounds and fossil hunters from
across the planet.

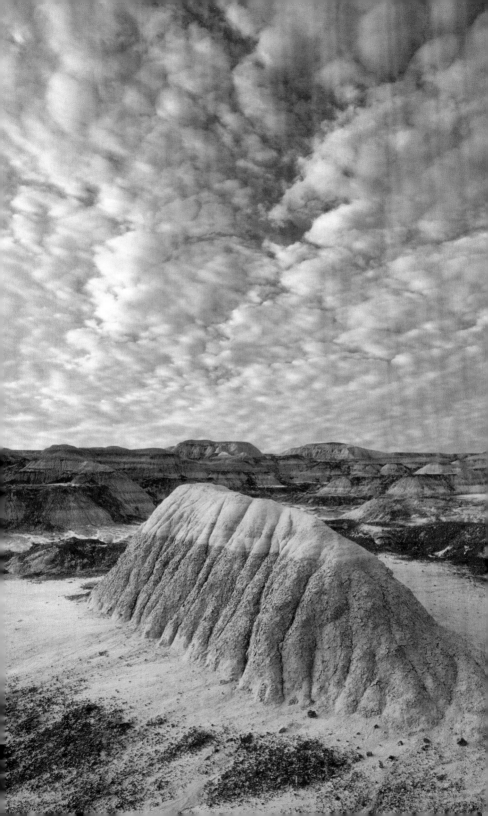

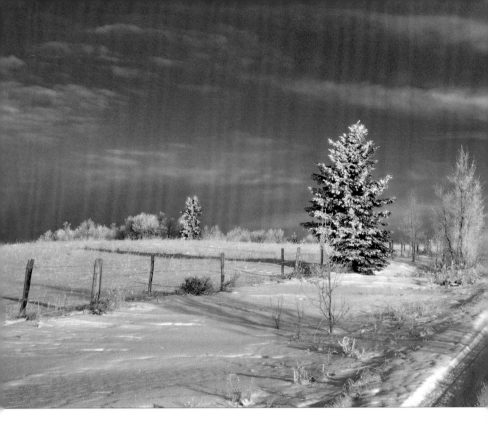

above:
A prairie road is etched through fresh snow and vast range lands, near Cochrane.

right:
A lone spruce tree stands cathedral-like in the ice fog of a January sunrise near Beaumont.

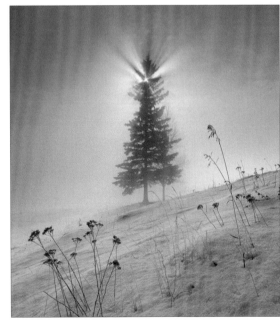

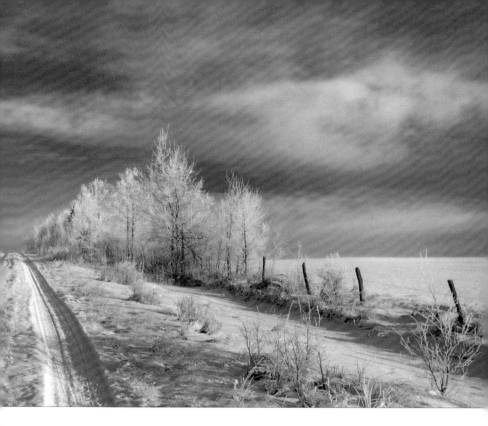

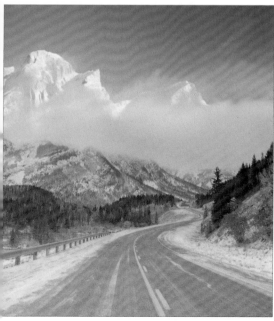

left:
An early September snow covers fall colours in a light blanket of white along the winding Highway 40 below Mount Kidd in Kananaskis Country.

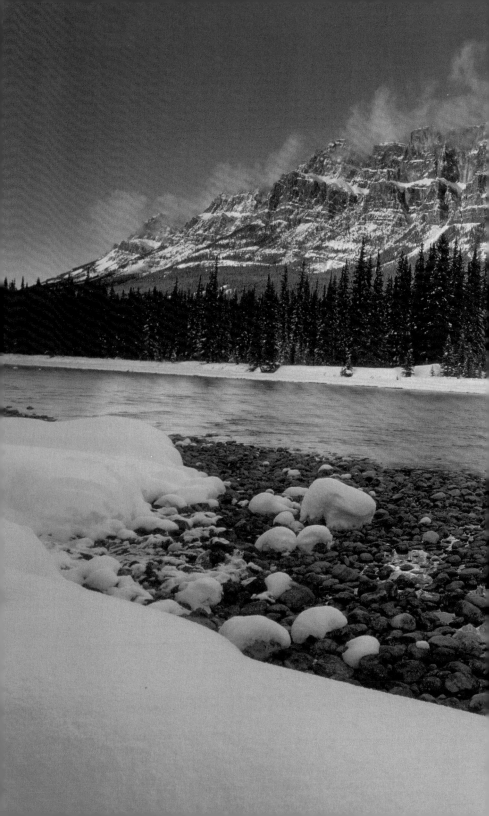

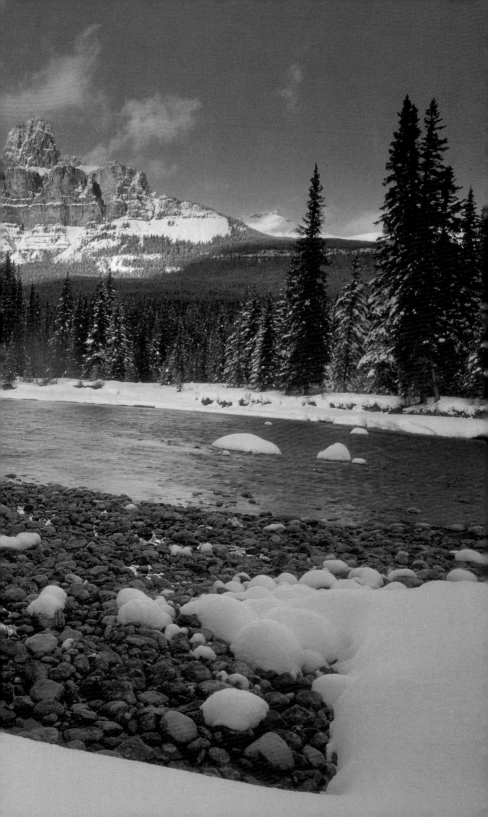

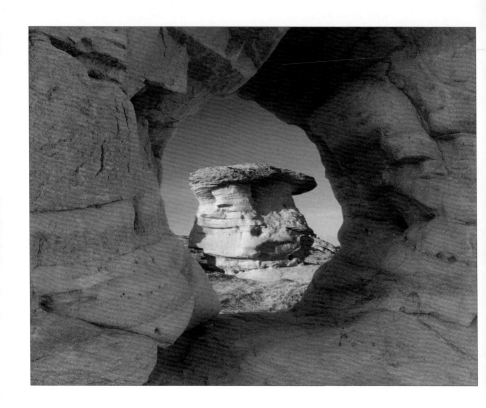

pages 60–61:
The orange glow of sunset highlights Castle Mountain
behind a gently flowing Bow River.

above:
Sandstone-capped rock formations are common
features of the Albertan badlands. A natural pillar of
rock, called a hoodoo, is theatrically framed by an arch
in Writing-on-Stone Provincial Park.

opposite:
Pendulous and colourful mammatus clouds hang heavy
over a field of circular bales at sunset on the outskirts of
Edmonton.

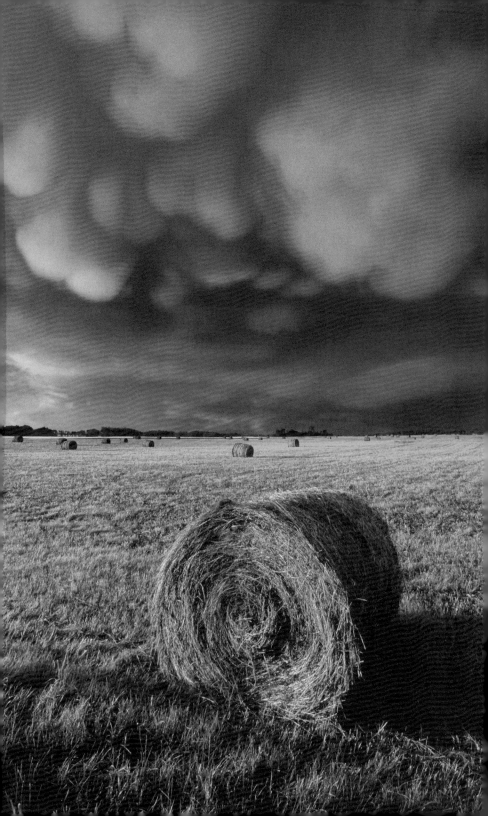

ABOUT THE PHOTOGRAPHER

Darwin Wiggett was born, raised, and continues to reside in Alberta. He has lived in Red Deer, Sherwood Park, Edmonton, Leduc, and Jasper. He currently resides in Water Valley. Darwin is one of Canada's top landscape photographers and has numerous books to his credit including *Dances With Light — The Canadian Rockies, Darwin Wiggett Photographs Canada,* and *Niagara Falls*. He also teaches photography workshops and courses. For more information or to contact Darwin, you can visit www.darwinwiggett.com.

PHOTO CREDITS

All photos are copyright of Darwin Wiggett/Natural Moments Photography except for the photo on pages 46–47 which is copyright of Anita Dammer and Darwin Wiggett. Darwin would like to acknowledge Peter Jeune of The Camera Store in Calgary (www.thecamerastore.com) and Bob Singh of Singh-Ray Filters (www.singh-ray.com) for continued long-term support of his photographic endeavours. Gracious thanks also extend to Reg and Clara Wiggett, April Hamilton, Anita Dammer, and Samantha Chrysanthou for their love and support. Thanks also to Samantha Chrysanthou for editing early drafts of this book.